AMAZING
PAINTING BY NUMBERS

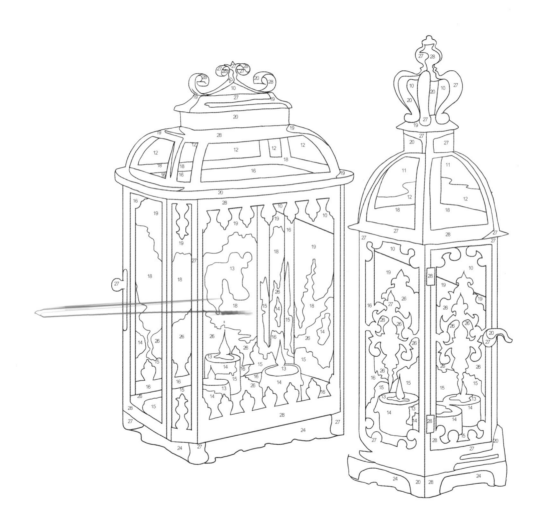

David Woodroffe

ARCTURUS

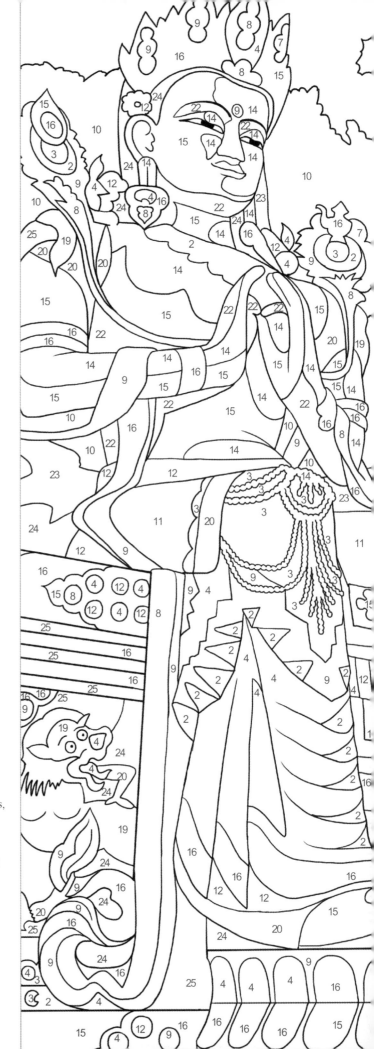

ARCTURUS

This edition published in 2021 by Arcturus Publishing Limited
26/27 Bickels Yard, 151–153 Bermondsey Street,
London SE1 3HA

ISBN: 978-1-78950-793-5
CH007288NT
Supplier 29, Date 0421, Print run 11037

Printed in China

Created for children 10+

Introduction

What makes an amazing image? Is it sheer beauty, or the magnificence of its architecture, or the achievements of the person it represents? Here are some truly amazing sights for you to paint, from the basalt columns of Giants' Causeway to the extraordinary achievement of the Great Wall of China, and the massive sarsen stones of Stonehenge. There are amazing animals including killer whales and an aerodynamic penguin, along with leaping salmon on the way to their spawning grounds and an elephant in its east African habitat.

Painting by numbers is a great way to begin to exercise your artistic talents and gain confidence in using paint, as well as an understanding of how an artwork is constructed. The illustrations here are printed on heavyweight art paper suitable for a range of different kinds of paints.

Each image is fully numbered so that you can build up an impressive artwork. Using the key on the cover, match your paints to the key. If there is no number that means the space should be left white or filled with white paint. Painting these images, especially the more complex scenes, will take time and patience, but it will be very rewarding to see your pictures take shape – and it will help build up your confidence in your ability to handle paint.

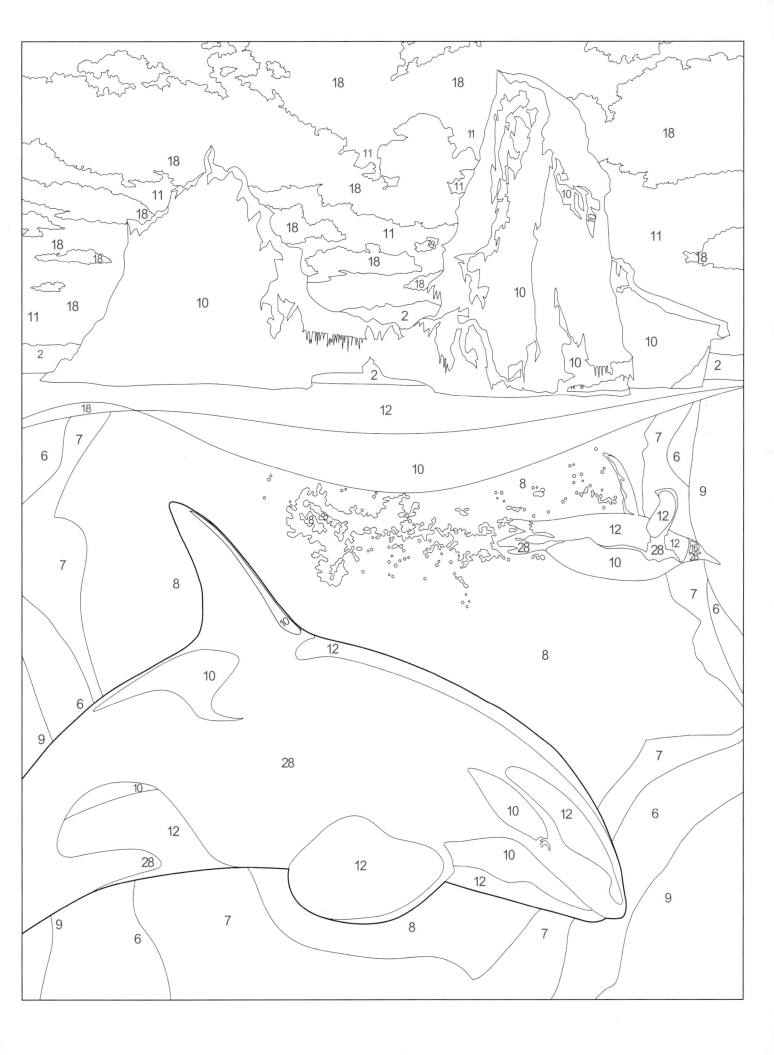

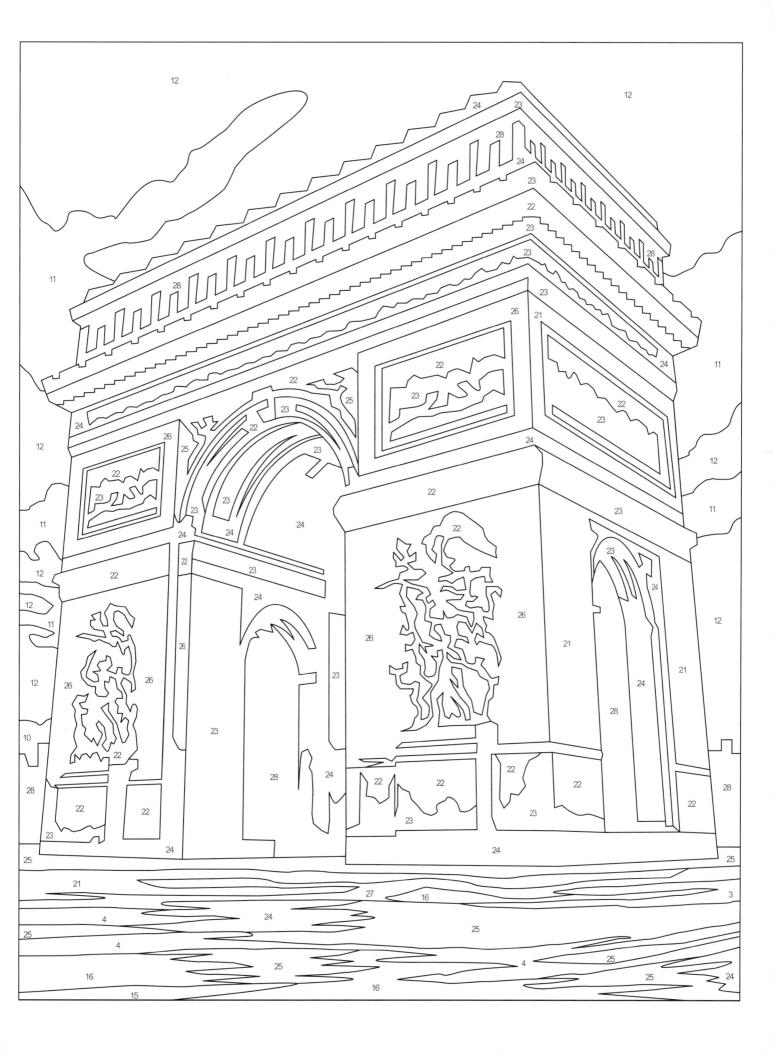

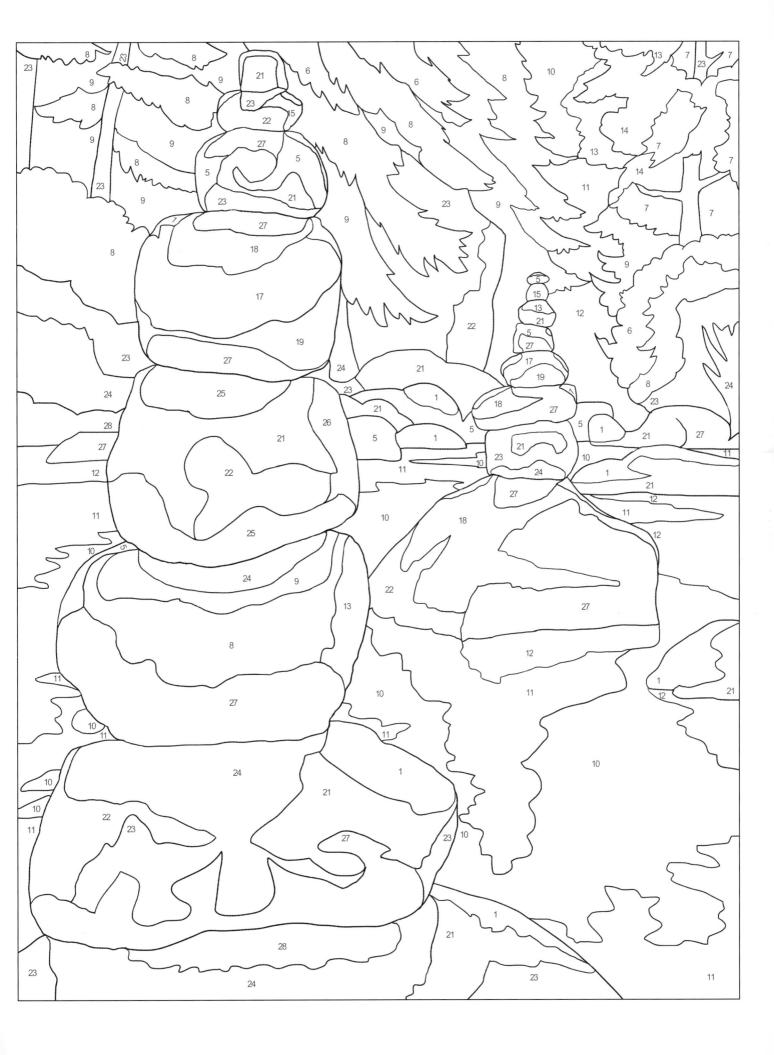

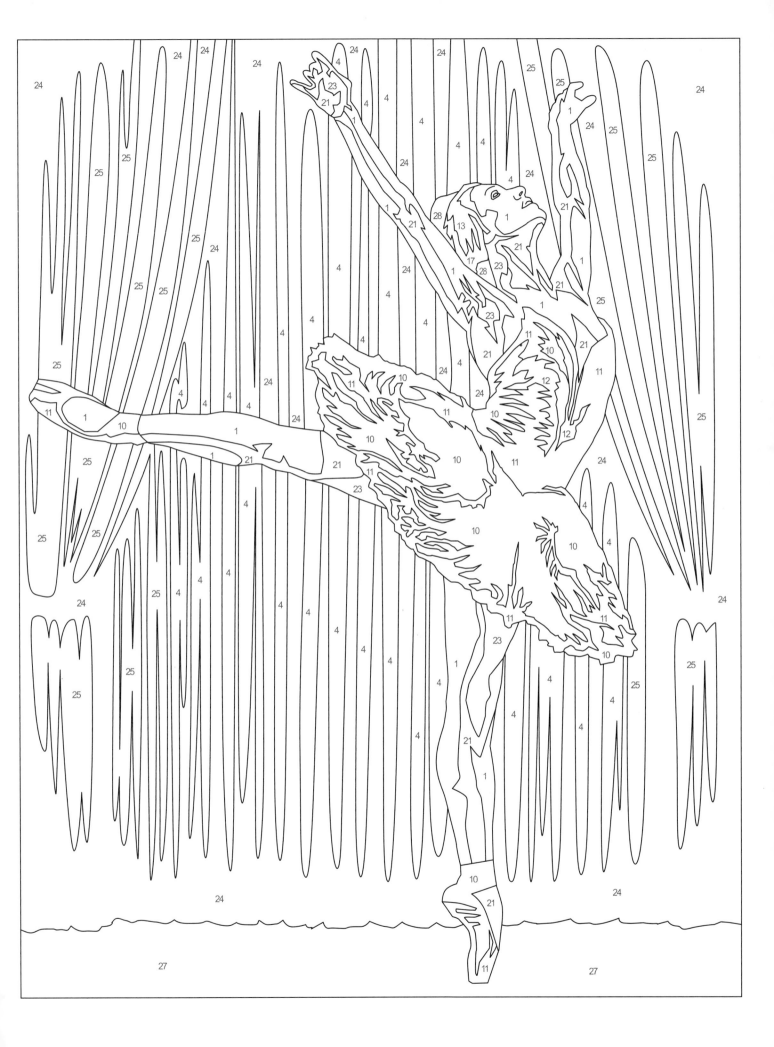

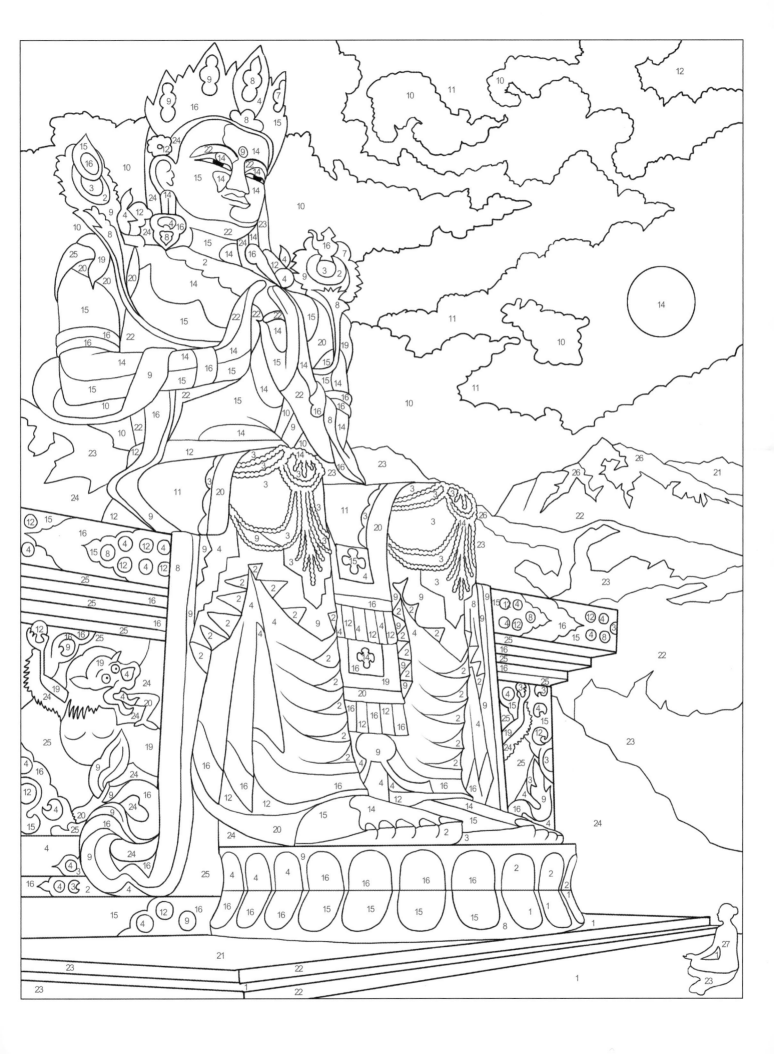

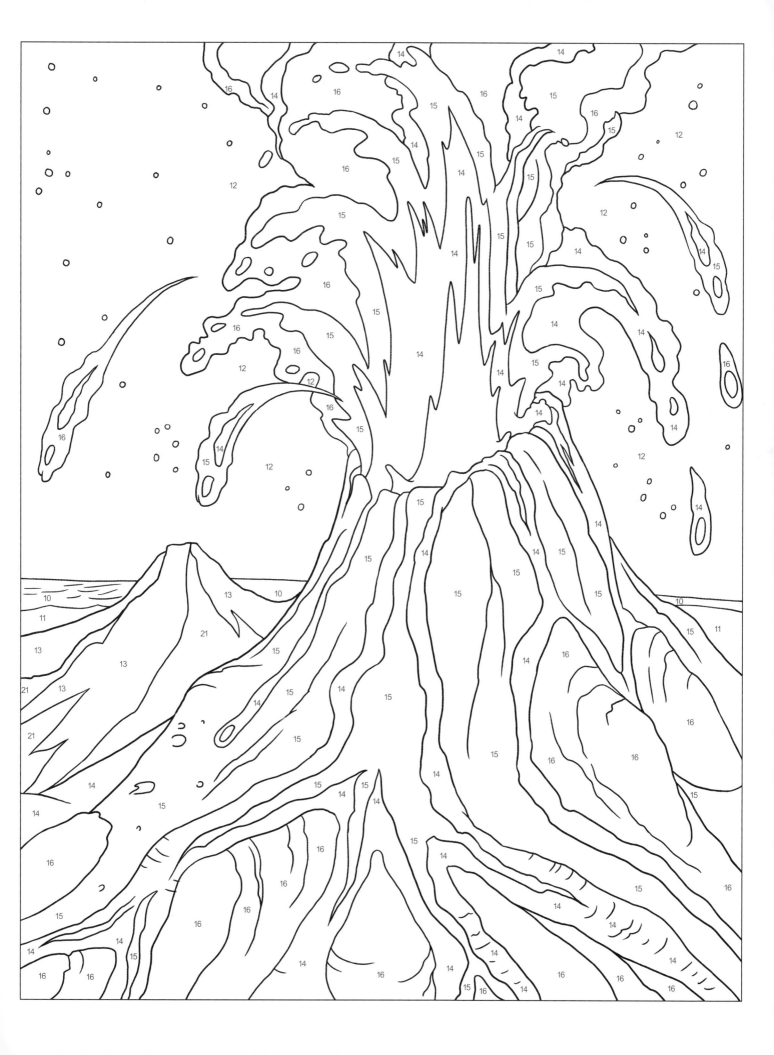

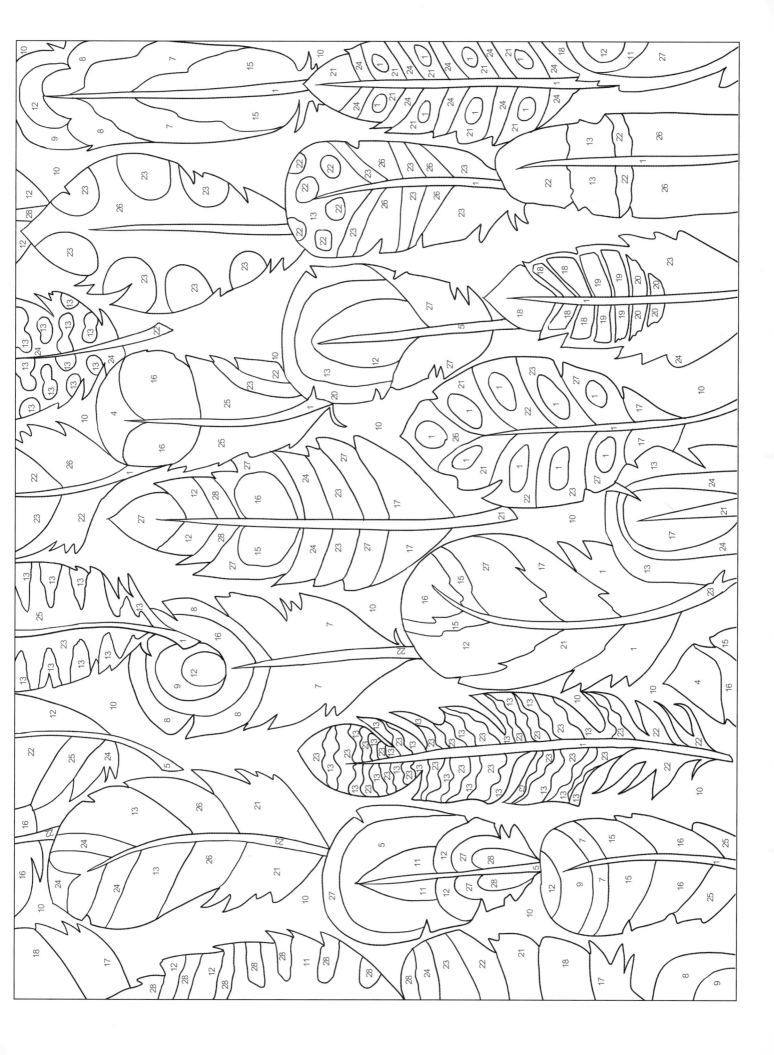

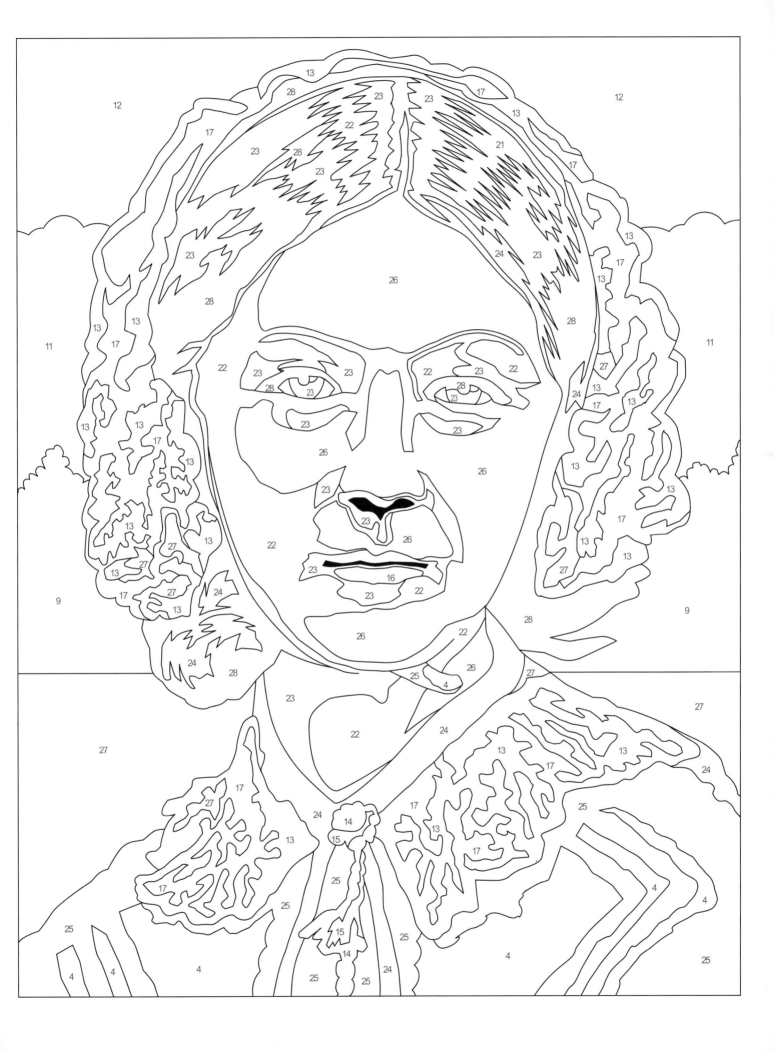

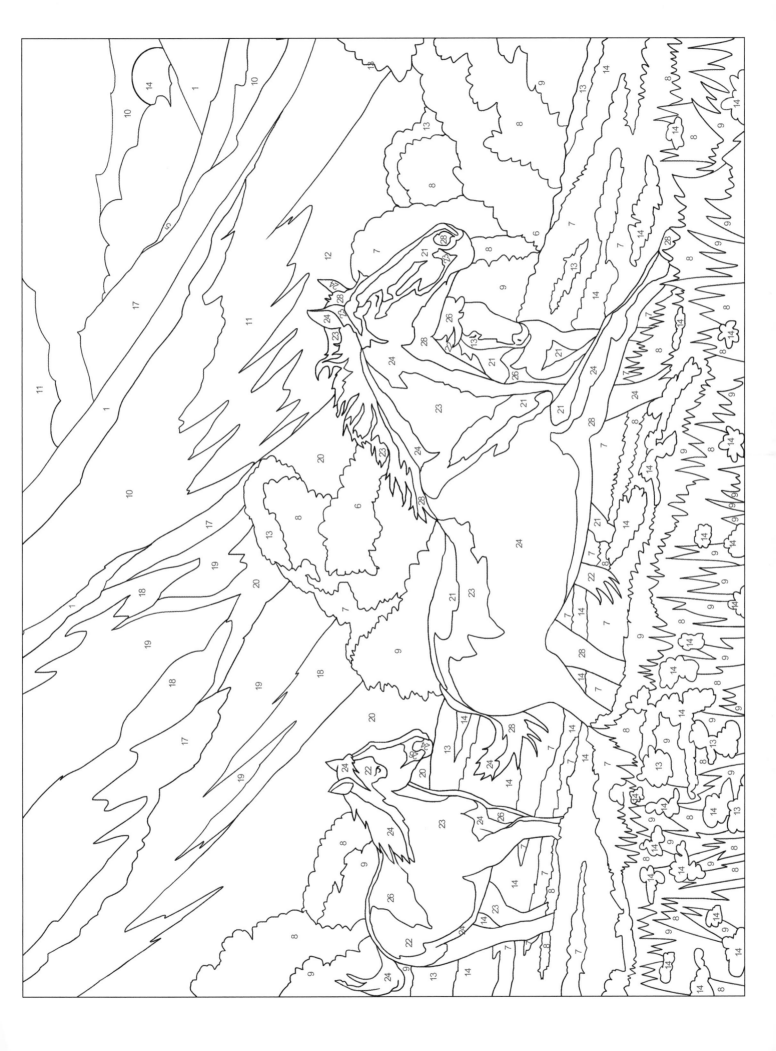

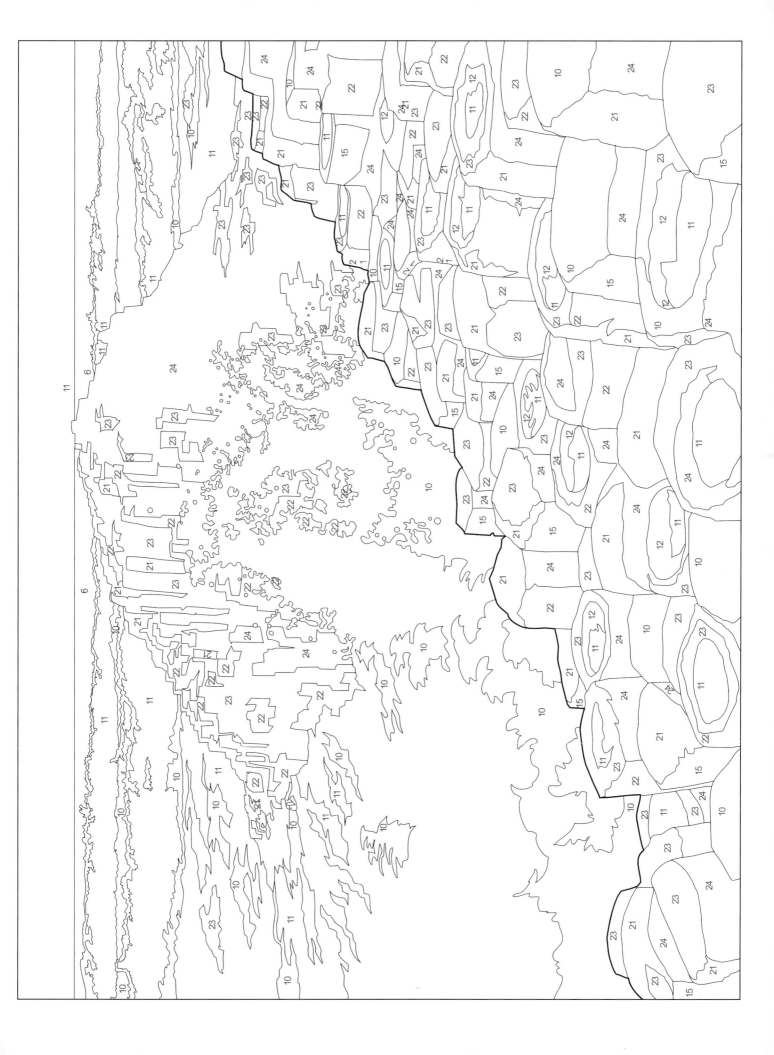

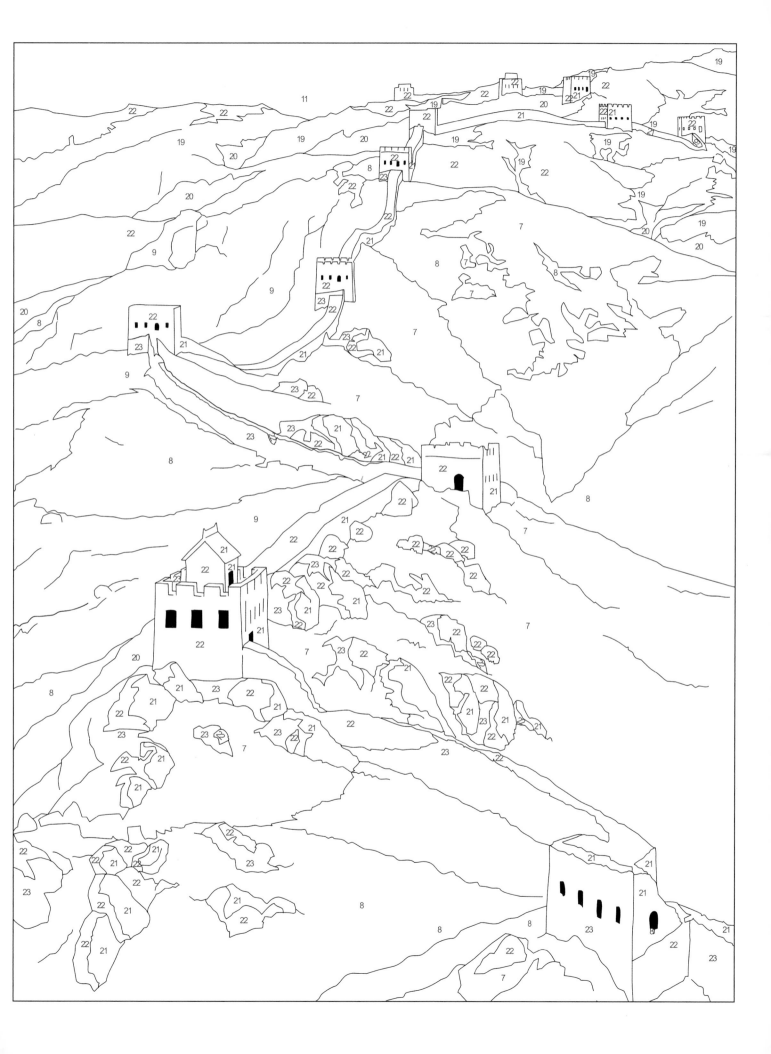

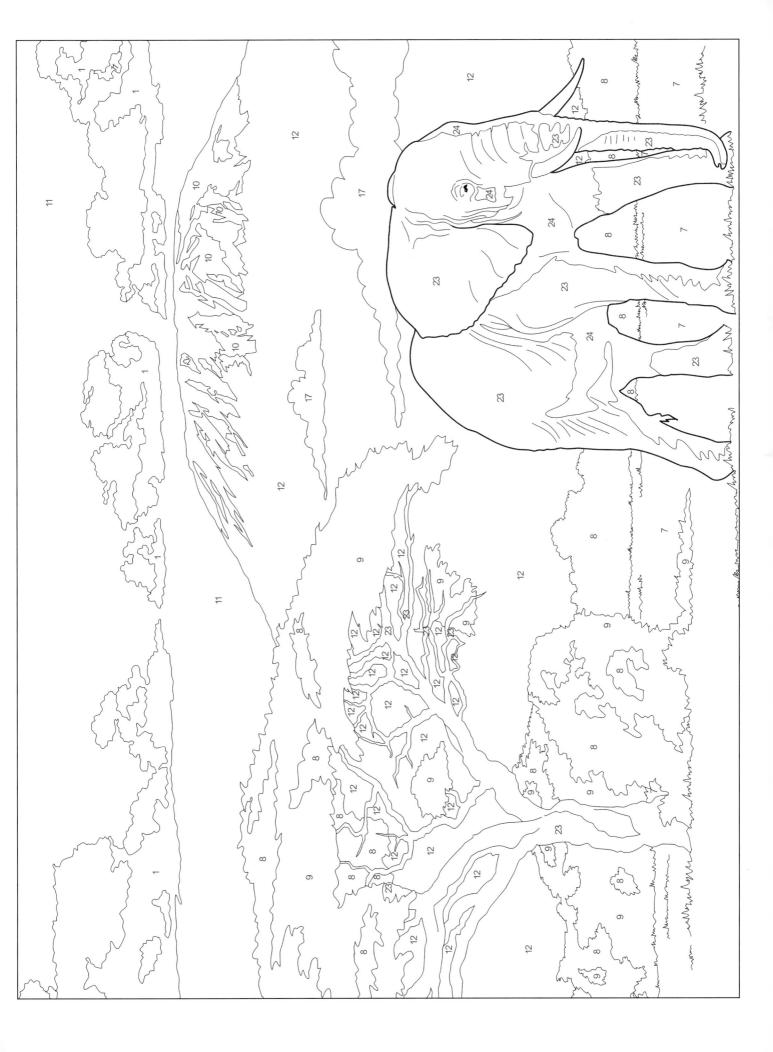

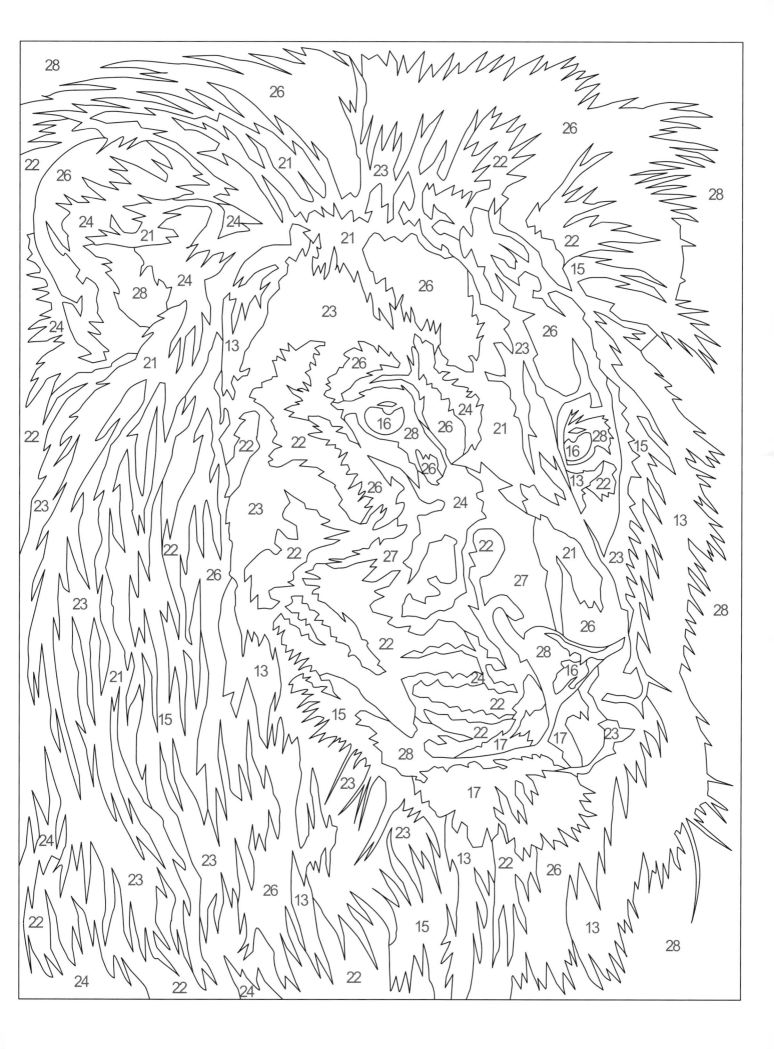

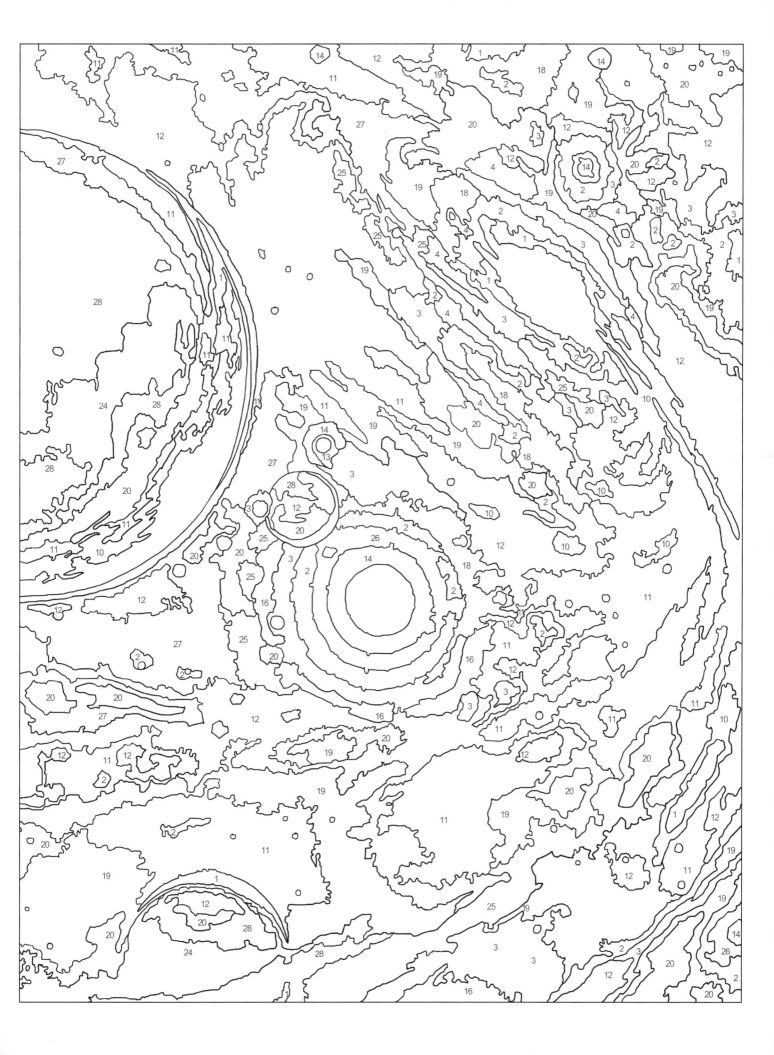

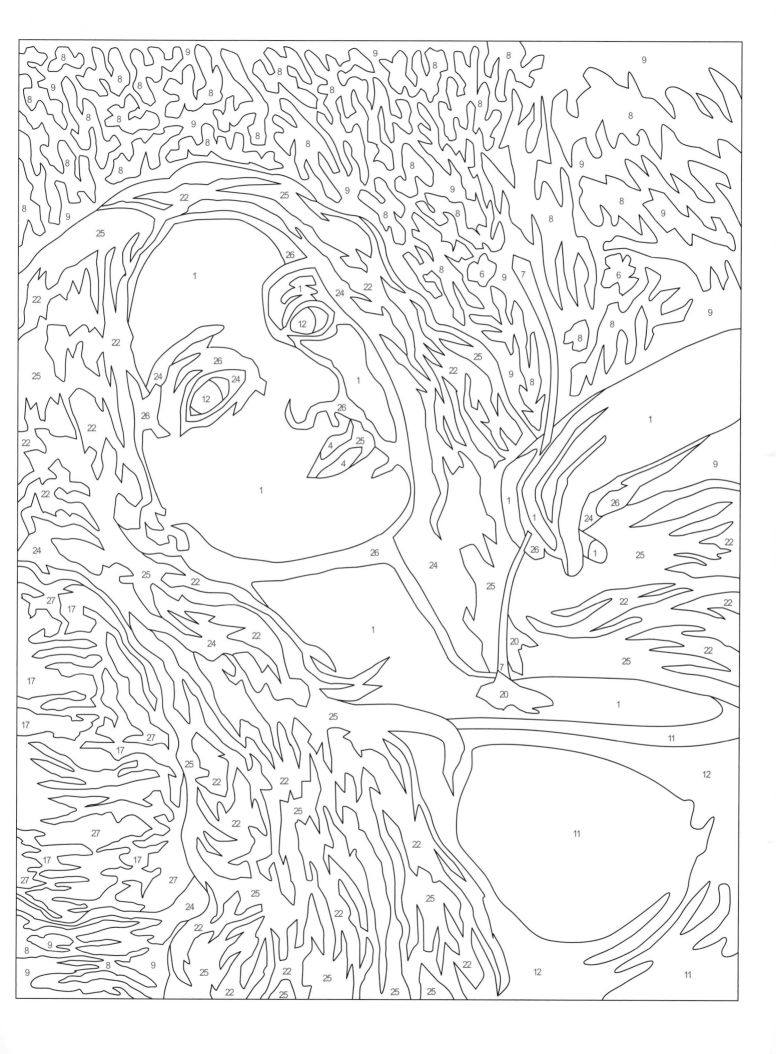

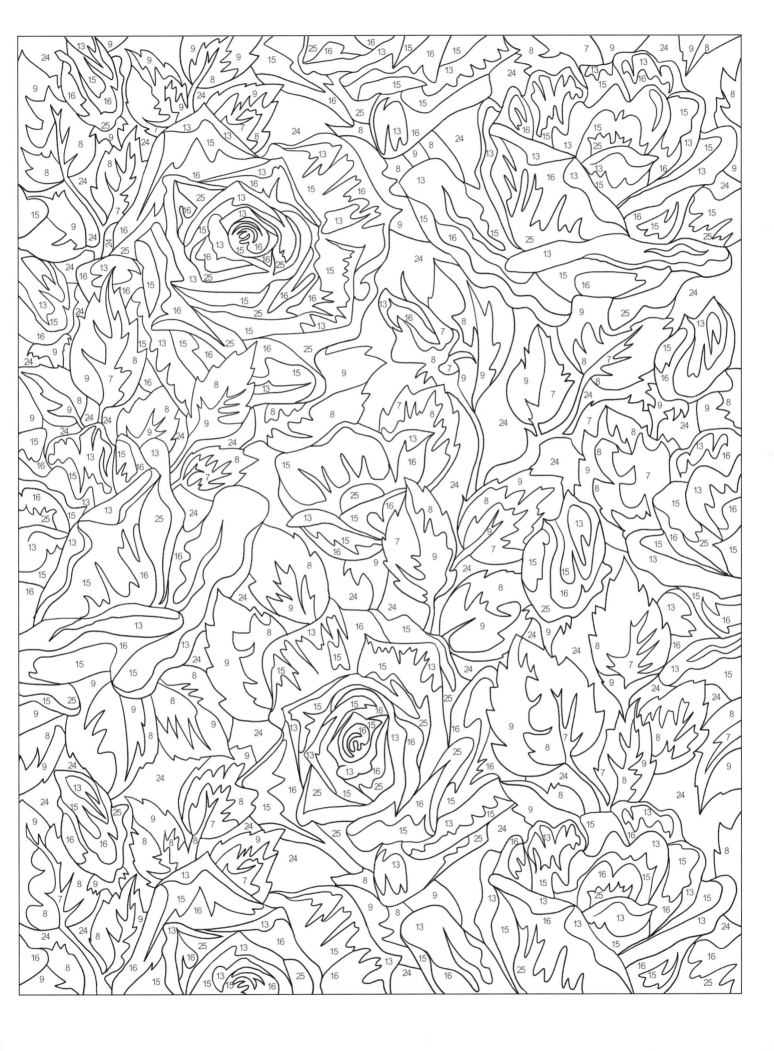

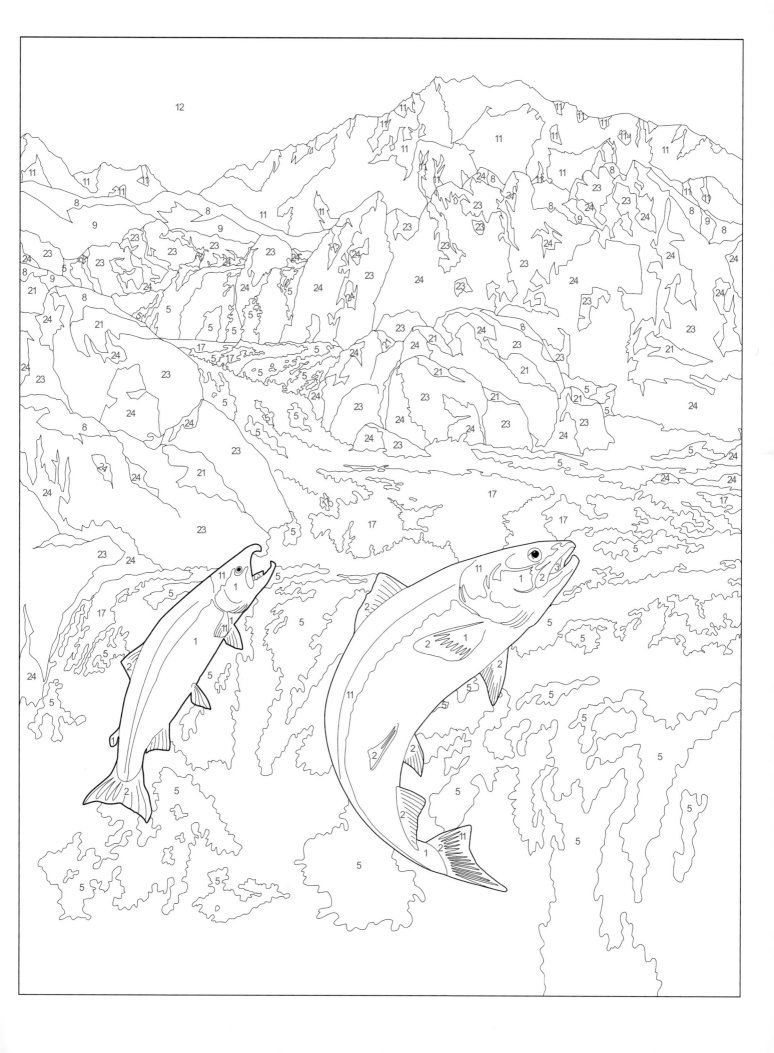

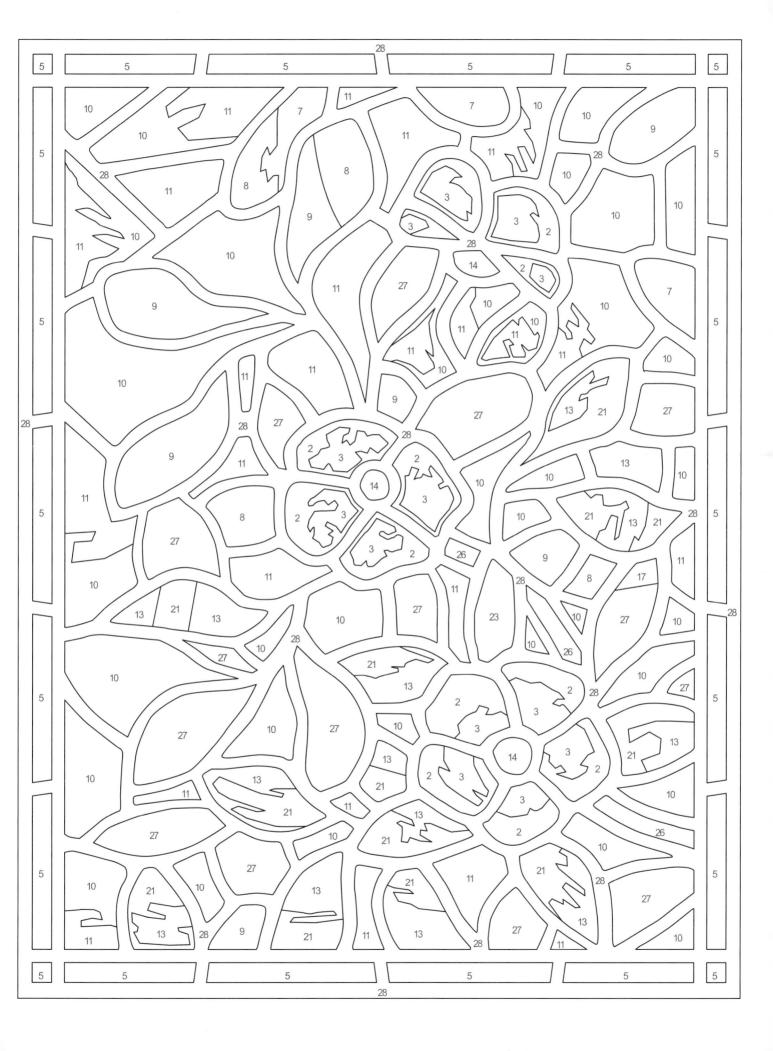

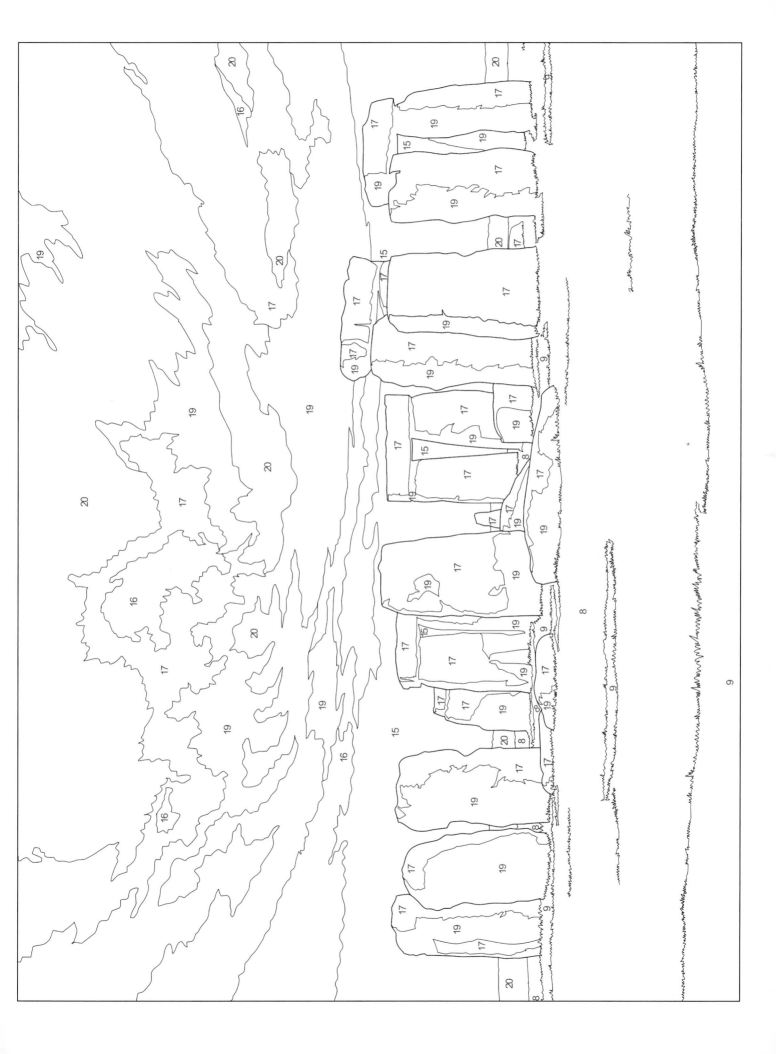

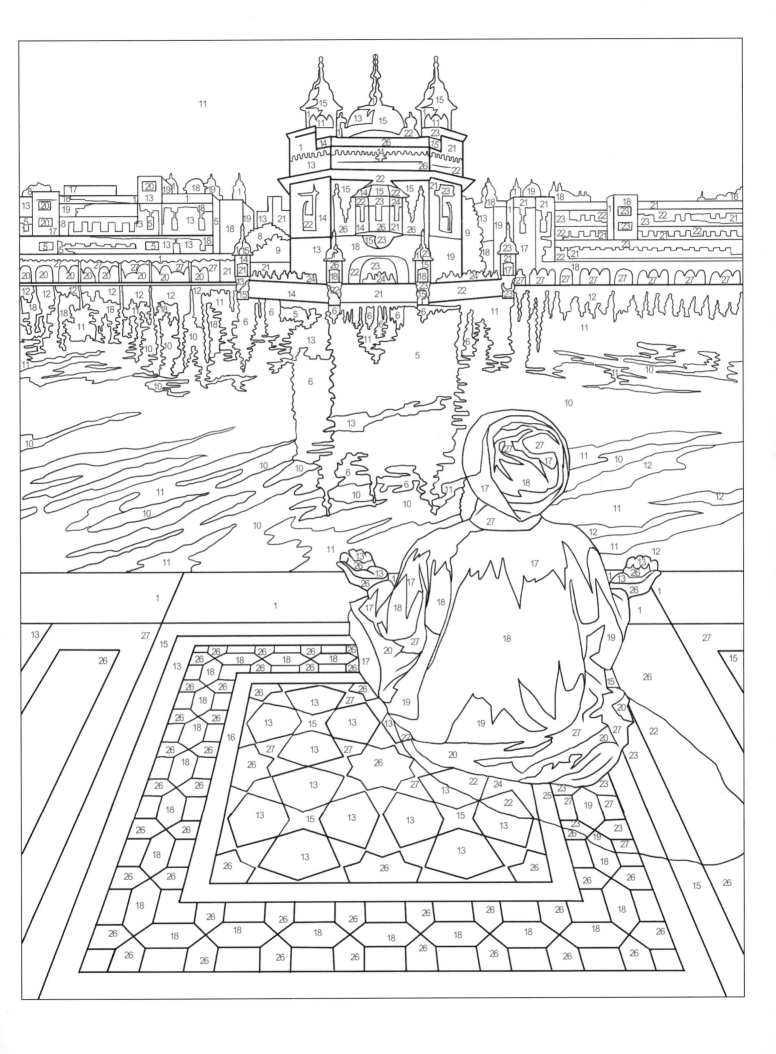

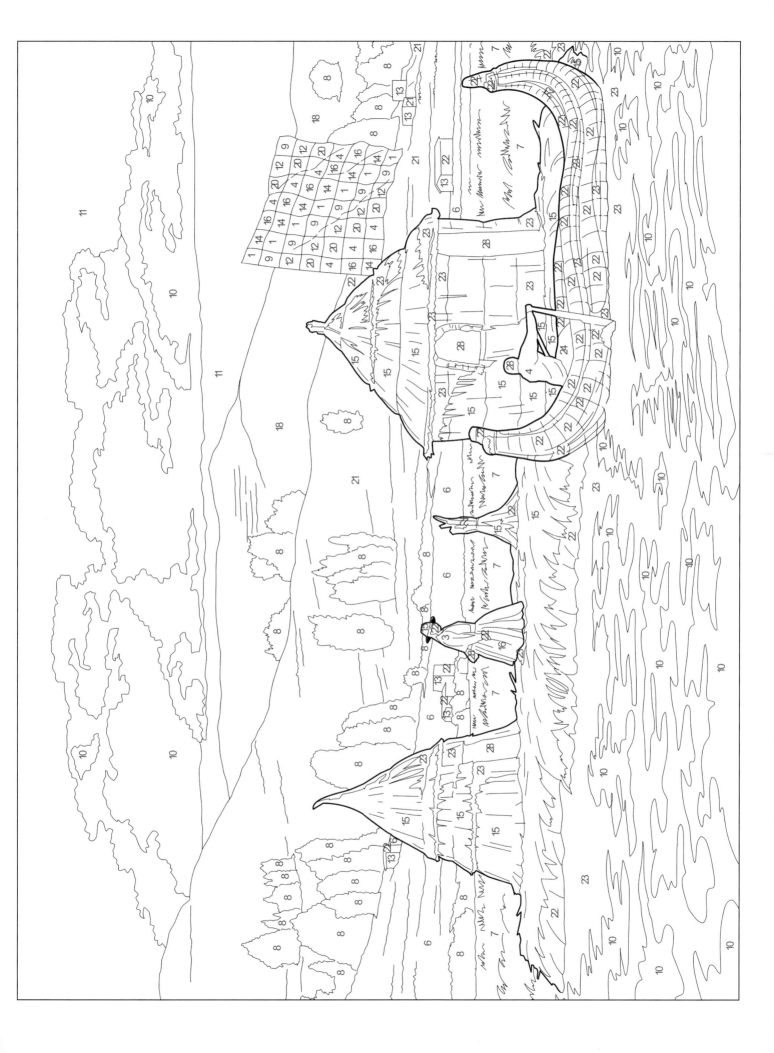

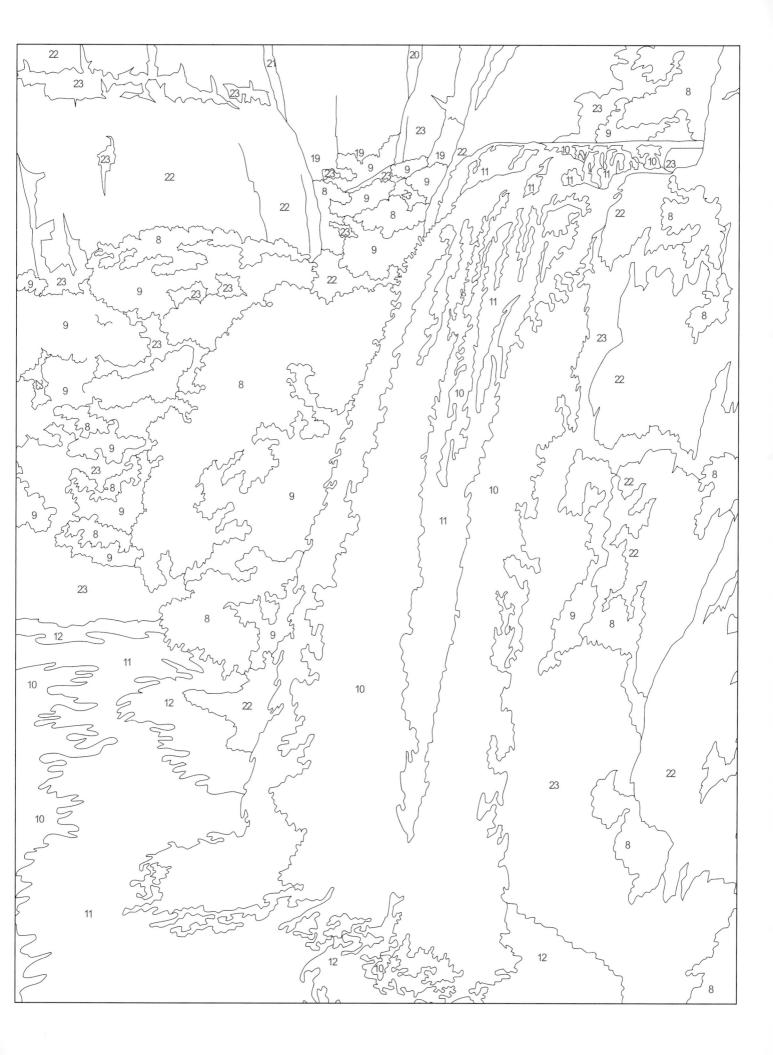

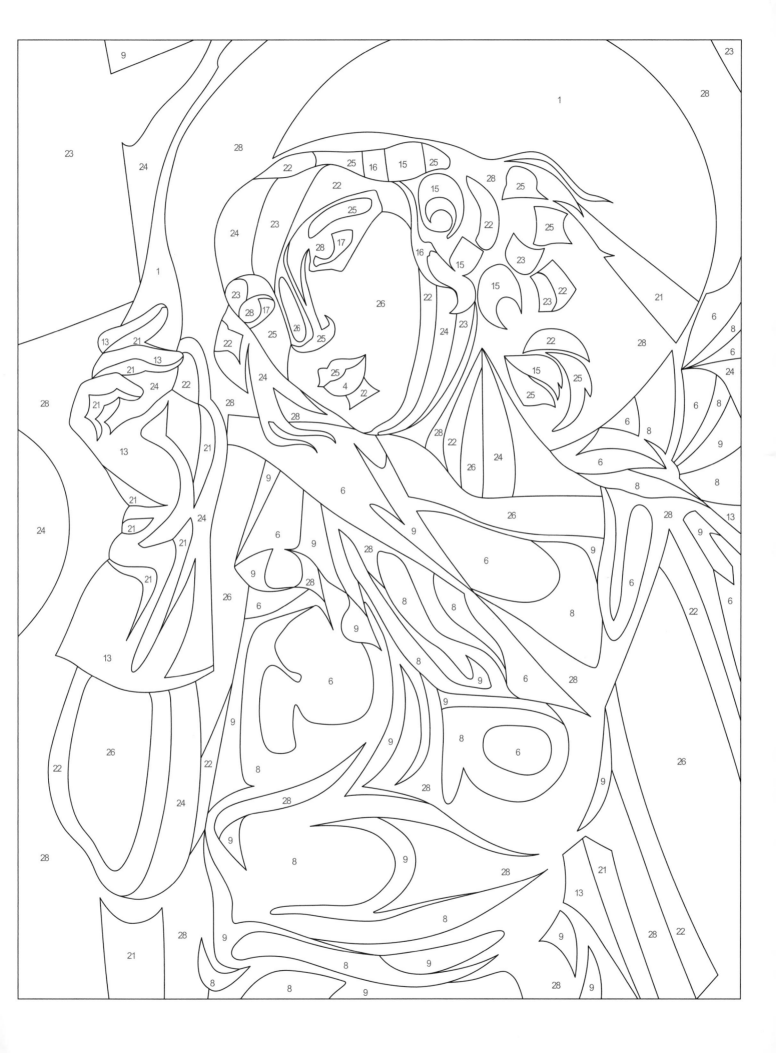

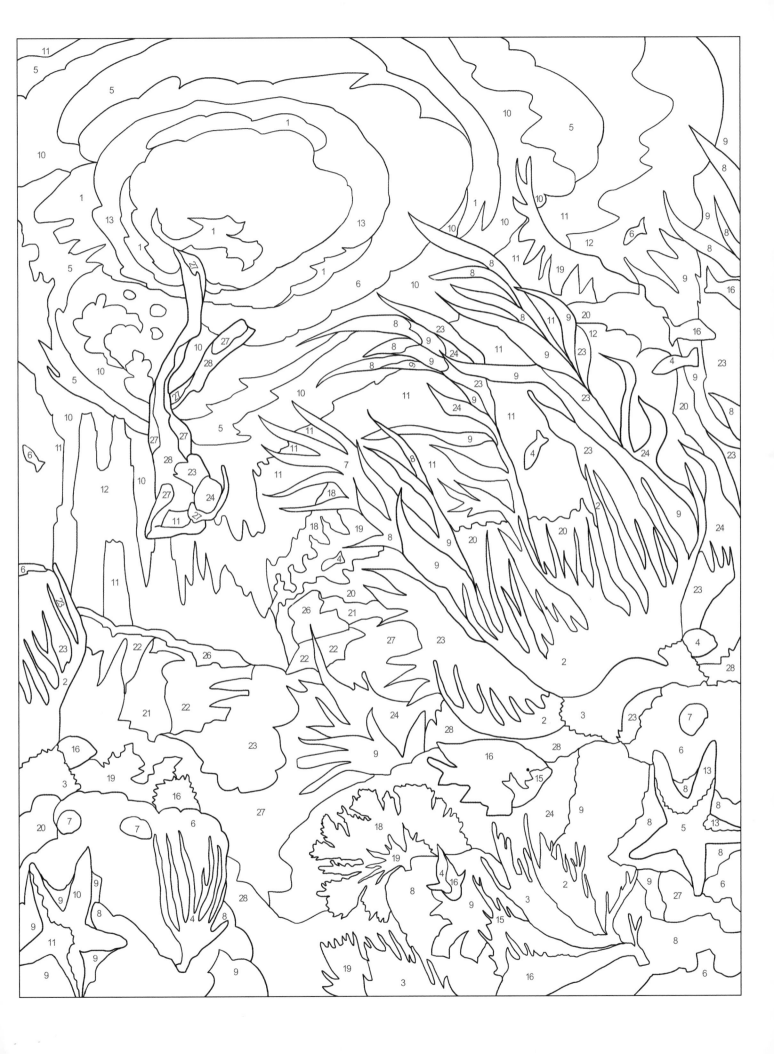

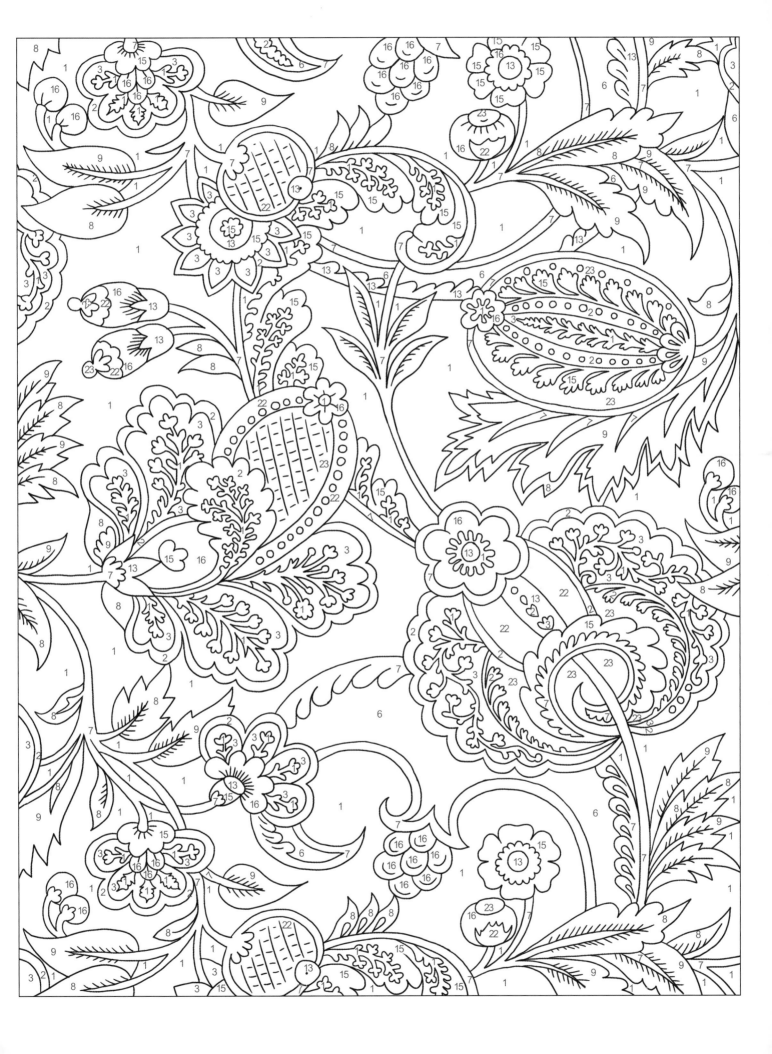

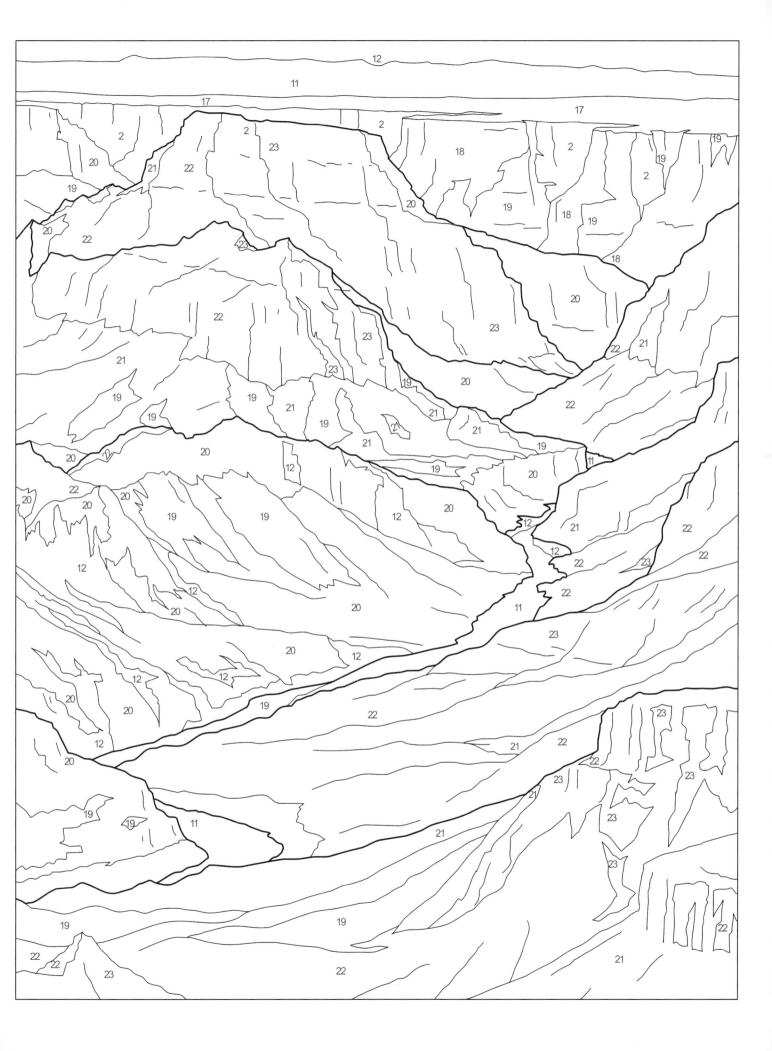

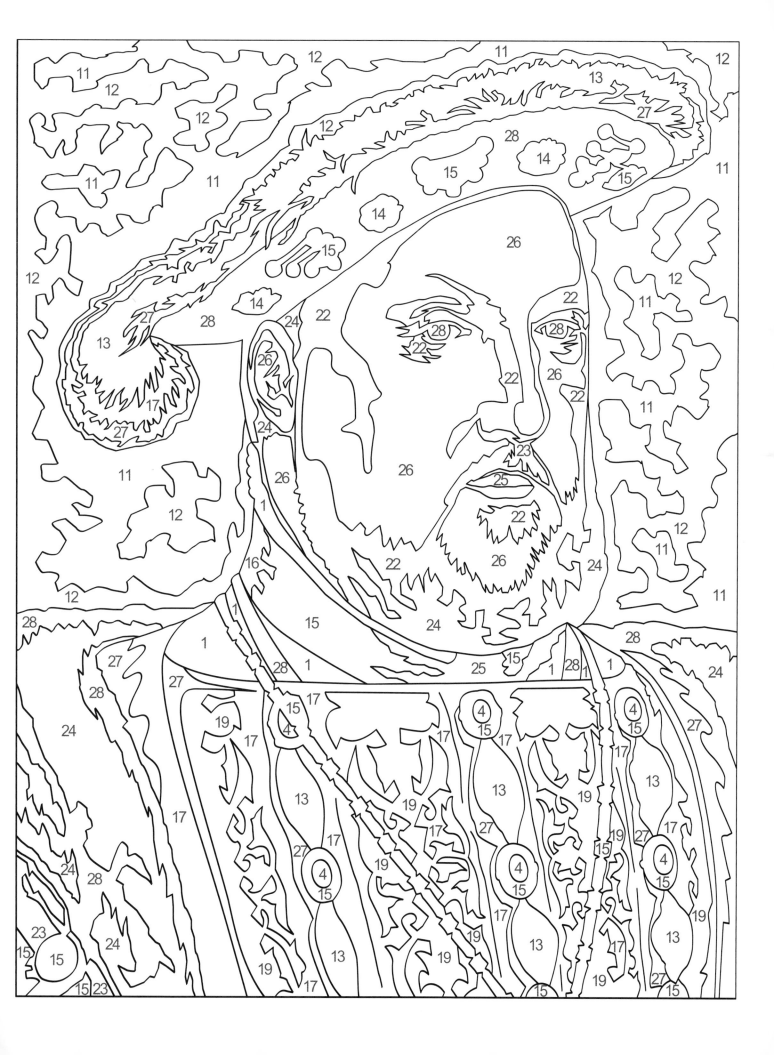

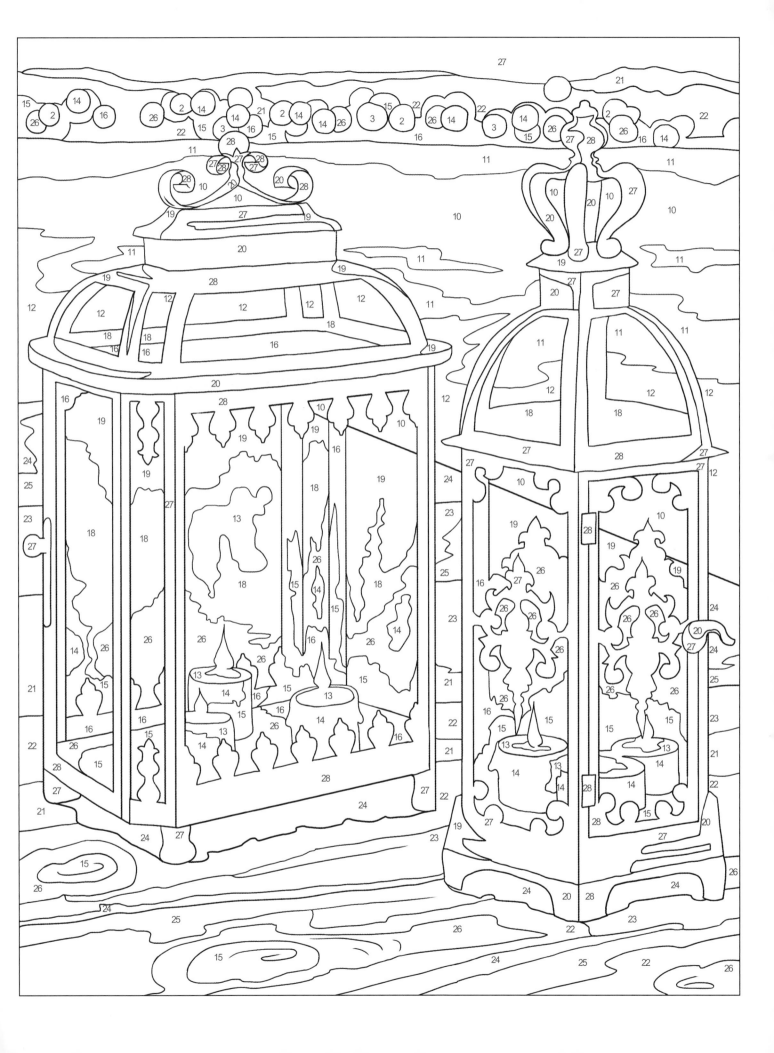

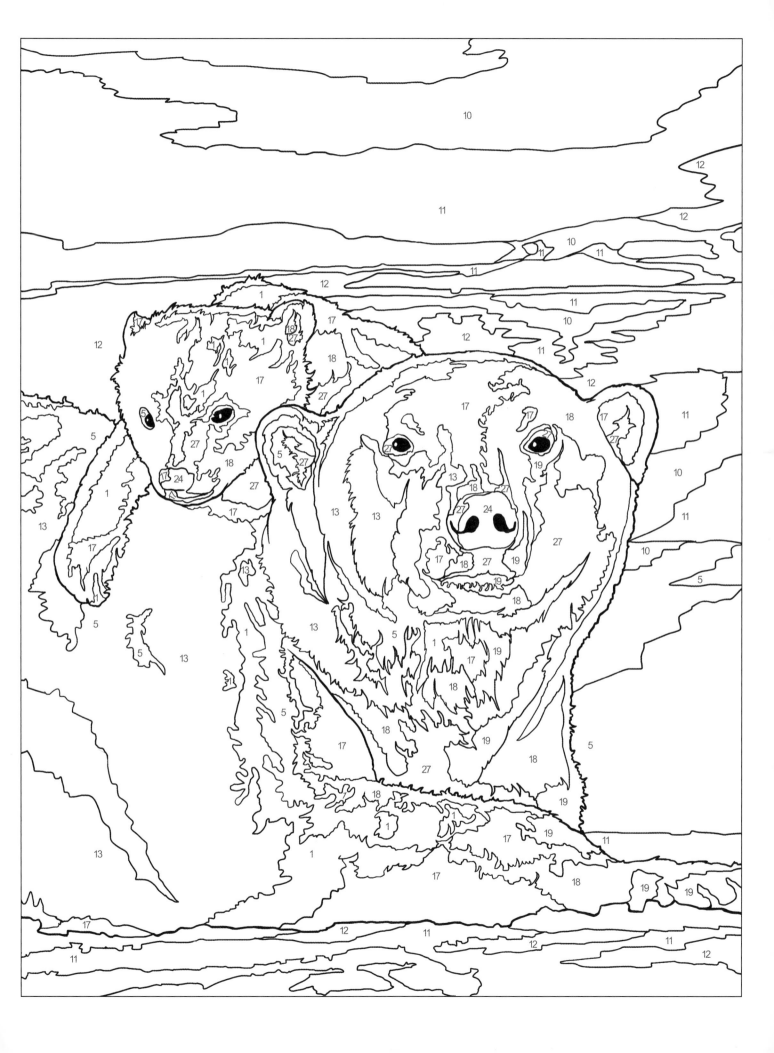

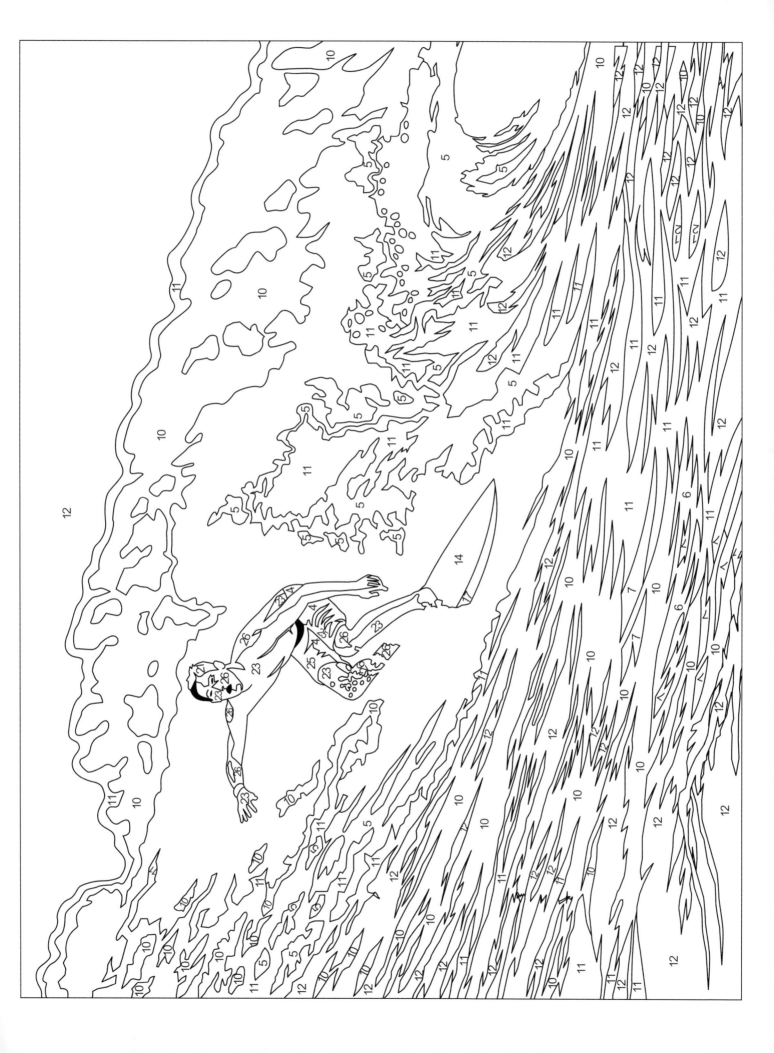